Important Things

Melissa Springer

CRANE HILL
PUBLISHERS
Birmingham, Alabama

Published by Crane Hill Publishers, 3608 Clairmont Avenue,
Birmingham, AL 35222; www.cranehill.com
Printed in the United States of America

Library of Congress Cataloging-in-Publication Data

Springer, Melissa.
Important Things/by Melissa Springer.
p. cm.
ISBN 1–57587–061–4
1. Photography, Artistic. 2. Springer, Melissa. I. Title.
TR654.S67 1997
779'.092—dc21 97–39830
 CIP

10 9 8 7 6 5 4 3 2 1

Foreword

What object holds the most meaning for your life? What represents everything you hold precious? What will you keep for as long as you live, carefully boxed and moved from place to place as situations change: a lock of hair from your long grown-up baby, a ring your mother once wore, a photograph? Perhaps it is something that doesn't last: a fresh flower, a handful of water, or comforting chocolate. I asked a number of people to let me photograph them holding their most precious object.

Some came to my studio with things hidden in pockets, revealing them only under the dim modeling lights of the strobes. I set up black seamless paper. They sat on a stool behind it and extended a hand through a hole in the dark paper. I could not see their faces, and they could not see me. It was a private act of confession.

I also traveled and asked strangers what they would like to hold. In India I relearned the lesson that food is the first important thing—to wake up and go on takes nourishment.

Not far from where I live in Alabama, I met a woman whose father had been born a slave—to be free is important.

Some people chose things that held loss. The objects make a safe place to hold sorrow. They are brought out into the light only when one is strong enough to endure.

I gave no instructions to people. They could choose whatever they wanted.

What would you hold? Remember, there are no rules.

Dedicated to
Nancy Woodhull

In Colquitt County, Georgia, my three-year-old mother watched her daddy walk down their dirt road to join the merchant marines. He never came back. Ben, her first stepfather, left in anger. John drank. By the time Thomas, her last stepfather, moved in, my mama had already run. At fourteen, she was a grade-school dropout and independent. Five years later, she married my father. I ask her what, after forty-five years of marriage, is her most precious object. I already know the answer. Just released from the hospital, my mother walks slowly to her bedroom. Returning with a small picture frame, she looks down at the grade-school pictures of her three daughters and softly reveals, "I wanted my own family. A family that wouldn't leave."

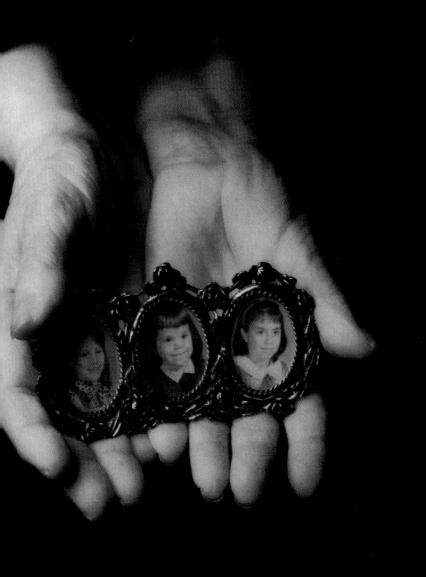

Stay with me.

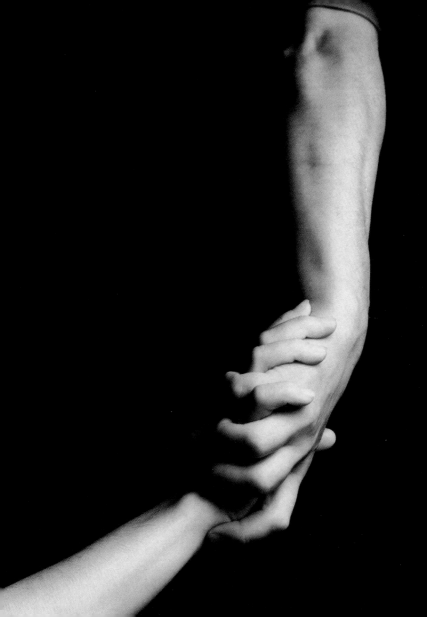

She has been married to the same woman for eighteen years. There were no ceremonies, no church, no family blessings, no bridal showers, no rings, no reception, no invitations, no honeymoon, and no gifts. Only a quiet commitment, contained in their home. The first five years were hard. They each sought to find their place in the world and in their relationship to each other. On their fifth anniversary, they exchanged commitment rings. "Our relationship seems stronger since we started wearing the rings." An outward symbol of an inward grace is a sacrament. Rituals help us define ourselves. To repeat "with this ring, I thee wed" gives a relationship acknowledgment in the community.

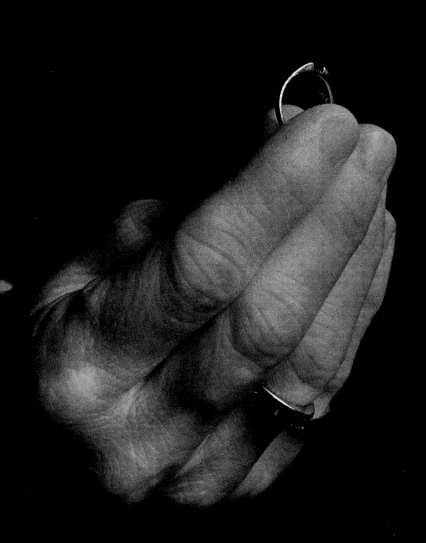

In touch is healing. In touch is comfort. In touch is acknowledgment. In touch is the sweet spirit of Jesus. She blesses me seven times, she anoints me seven times, she feeds me Communion seven times. She serves me unto perfection and sends me home with seven angels.

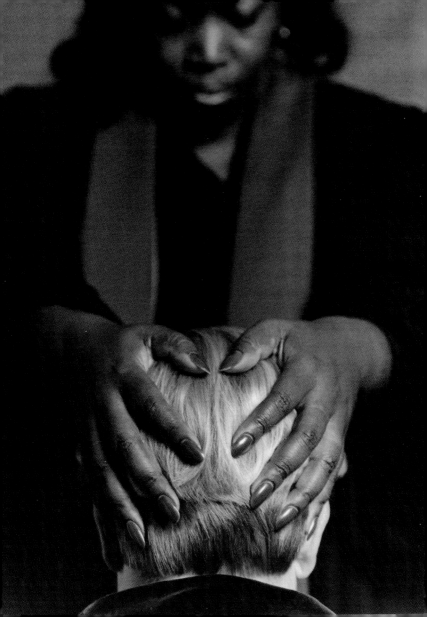

Fragile, thin as a willow tree, he has carved his bark with pictures. Tattoos cover his young body from top to bottom. With a long finger he traces the time line of the pictures. His body is a diary, lest he forget a painful lesson or a joyous moment. At fourteen he began to write his life story with needles and ink. At twenty-two he is still a sapling, and his epic is running out of room. May he grow taller and stronger.

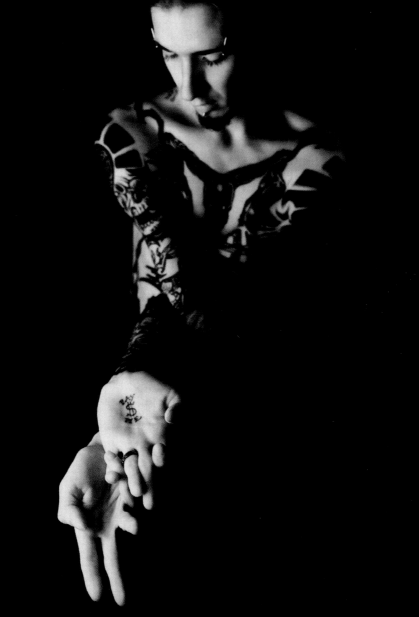

Upon receiving the ring, wrap mate tightly in arms.

When sleeping, touch heads together to share dreams.

When making love, listen to sighs. Inhale—take in the breath of the spirit. When angry, use gentle language. When lost, cry out loudly. When happy, dance. If you begin to feel alone, walk home. When in doubt, love, honor, and cherish. Don't discard. When aging begins, enjoy. Upon death, softly kiss good-bye.

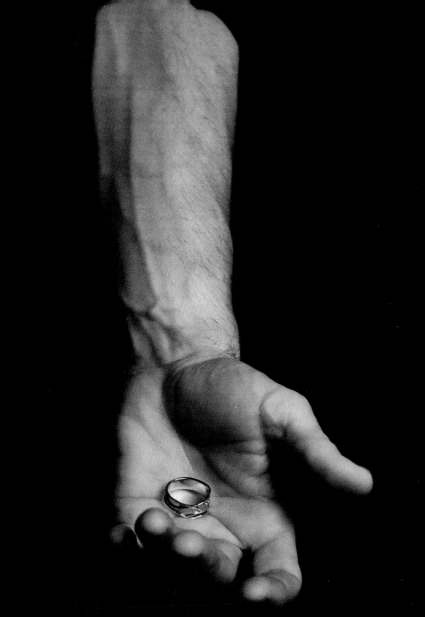

He has no memory of his father. When he was twelve, his father died of a heart attack. Now, as an adult, he says, "I can remember things we did together, but I can't remember him being there." Around his neck, the son wears his father's and his grandfather's dog tags. He is their namesake. These thin metal plates embedded with his name retain all the things he cannot remember. They gather comfort like dust. When wounds are so massive that the face cannot be recognized, it is the dog tags that identify the dead.

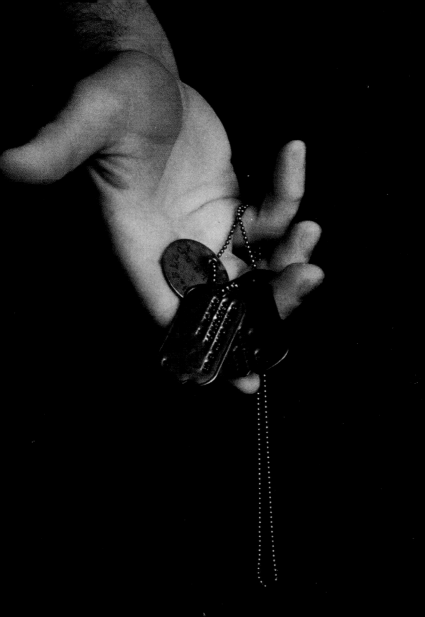

Moments before she is taken into surgery to have her breast removed, she hands her husband a letter. As she begins her fight for life, he reads of their life together before the cancer. She is thanking him. The letter carries memories made together, celebrates the child they made, and sings of hope to create more memories. Two years later, he still carries it in his briefcase. Two more years of memories have been made. She is a survivor.

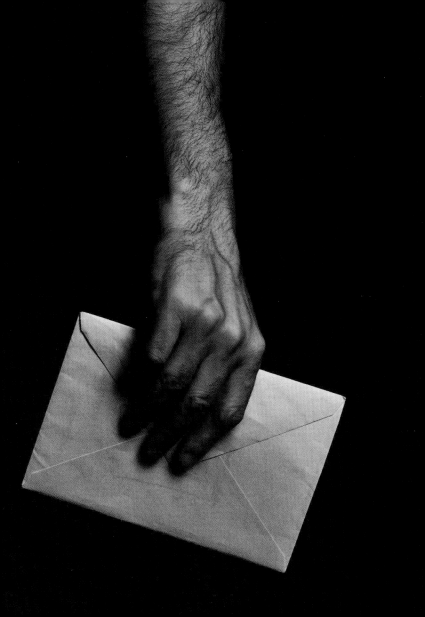

Fatigue marches home, and he is commanded to bed. The depression has returned. He knows the next few days will be consumed by dreams. He reads and rereads one sentence from his favorite book, *The Denial of Death* by Ernest Becker: "The most that any one of us can seem to do is to fashion something—an object or ourselves—and drop it into the confusion, make an offering of it, so to speak, to the life force."

A death row inmate's palm holds her lifeline.

This young college student carries a pill case in her pocket. It is a replica of an old design from the Vatican Library collection. "It gives me a sense of security just knowing that if I had any pain at all, I could instantly take out my pill case and take the pain away with a pill." The pill case is empty now. She is recovering.

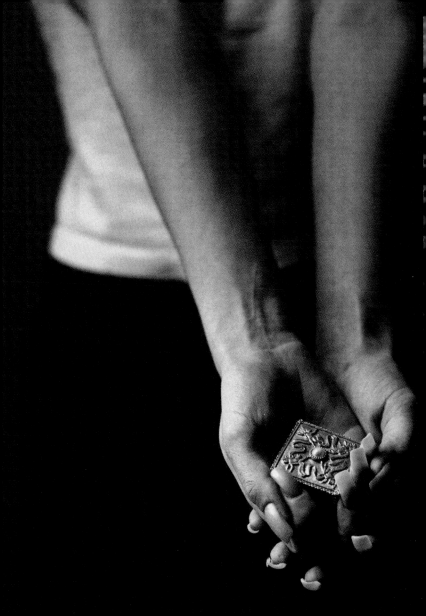

Under a bridge of Highway 31 in Alabama is the house that James built. Stained carpet covers the gravel, cushioning the floor. The bed, an old box spring and mattress rescued from the street, is neatly made up. Two pillows lie in symmetry. Three pairs of shoes line up proudly at the end of the bed. Extra T-shirts and jeans are folded with precision and rest in cardboard boxes. He has gathered old photographs to decorate and nursed abandoned houseplants back to health. No walls offer boundaries. Only threats keep visitors away. Air conditioning is either hot or cold, dry or wet, windy or still. When asked about his plans, he says, "To sit next to Jesus and look down on this world. To be one of His Angels."

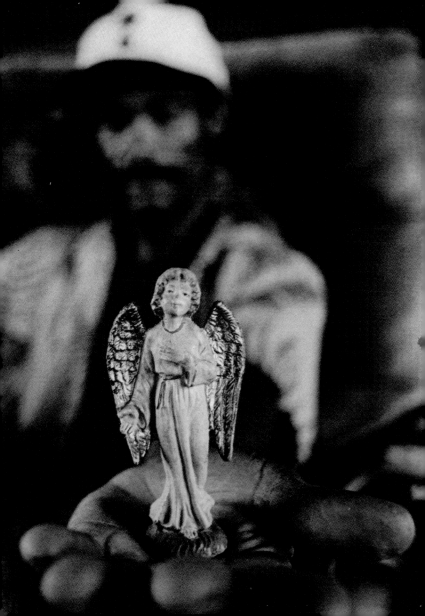

"I am important!"

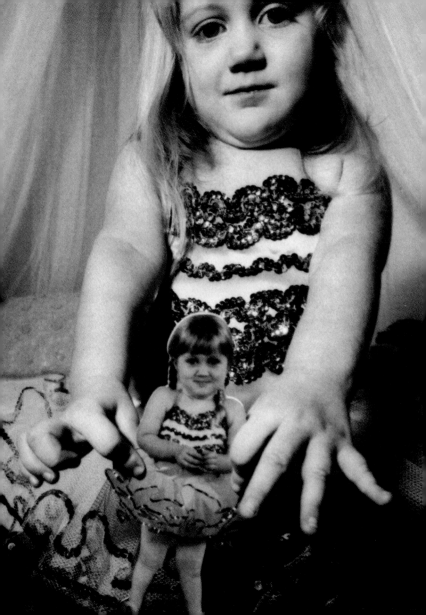

He carries a pocket heart every day. His lover leaves him hearts when he travels, a reminder that the one who stays is missed. To see men embrace, to see men display tenderness to each other, and to feel the love between them gives hope to this earth. Maybe, deep down in our genetic code, rests the ability of men to denounce war. Maybe, deep down in our genetic code, lies the ability for all men to act with gentleness toward wives and children. Maybe, deep down in our genetic code, hides the formula for all men to finally love one another.

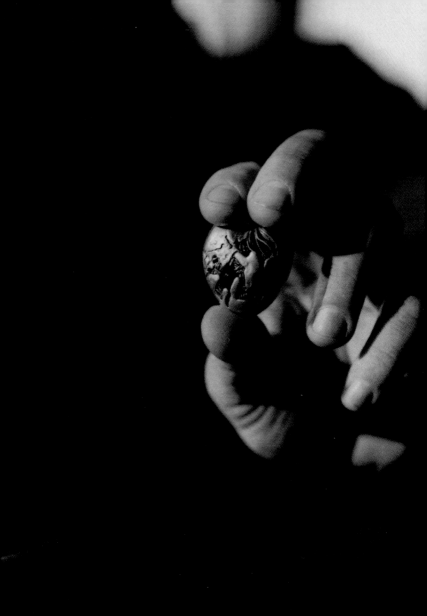

Remember adolescence? Remember school hallways full of teenagers gathered in tight groups? Losing the keys to unlock any of the circles? Wearing certain clothes to boast individuality, only to realize everyone has the same pair of jeans? His hat carries identity for him. It has been through everything—his first car, first kiss, first beer, first betrayal, and first time away from home. If he forgets who he is and where he belongs, this young man puts on his hat and walks back. Back home.

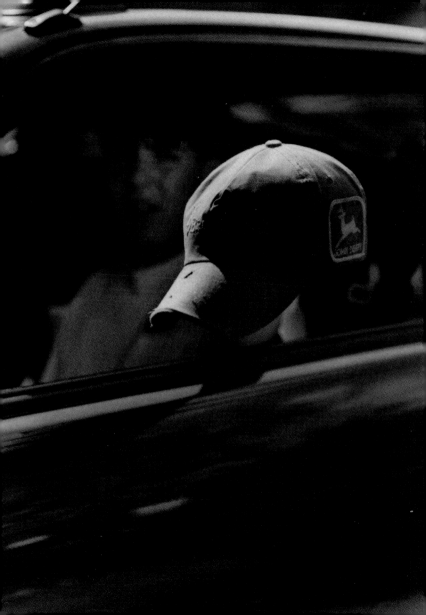

Sleep drifts away with the drowsy rocking of the tide as he wakes on his boat before dawn. First act, a cigarette. Moving his Star Rover quickly across the water, he looks for schools. No land is in sight, only the sea and the occasional glint of a tail, a teasing presence. He drives his boat and smokes. Last week Jack found a body floating alongside his anchored boat. Dressed in khaki shorts and a Ralph Lauren Polo shirt, the body looked like someone's husband—a man on vacation who slipped into the water. Jack called the coast guard, waited for the pickup, and smoked a cigarette. After a good day's catch, nets full of flipping silver grasping the sun's last rays, he smokes and feels satisfied. At night the seagulls are finally full and quiet, the moon's sliver hangs in its place, and darkness wraps the boat's hull in wet blankets. He looks out over the night's ocean and smokes a cigarette. Inhaling need, exhaling loneliness.

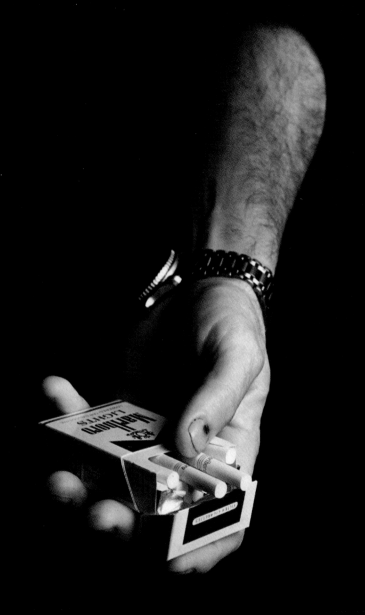

As a scholar he walked in muddy footsteps around Walden Pond. As a teacher he asked the right questions and questioned the answers. As a son he loved his mother. As a father he used his mother's recipe, kept safe in a box he made as a child, to bake the bread he fed his children. As a poet he makes every moment still.

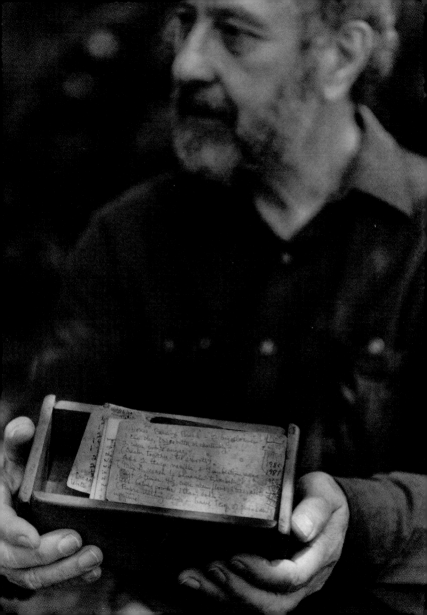

She is 102 years old. Her father was born a slave. All her life she has lived on the land he bought from his former master. She remembers walking miles with her mama to the store. It was a big store, with flour, sugar, candy, and bolts of fabric. Upon arrival, her mama would always sit young Bessie up on the counter to rest in a little chair. One day Bessie just decided that chair was hers, so the white shopkeeper sold it to her mama for fifty cents.

"It was the first thing I ever owned," she says quietly.

"And I still have it."

Baby sister meant her father wouldn't love her as much.
Baby sister meant baby-sitting. Baby sister meant her
father was building another family with his new wife.
Baby sister meant abandonment. Baby sister meant
dirty diapers.

Baby sister is born.

Baby sister means laughter. Baby sister means bigger
hearts for everyone. Baby sister means wide-open arms.
Baby sister means cuddles. Baby sister means complete
adoration of big sister. Baby sister still means dirty
diapers, but it's not so bad.

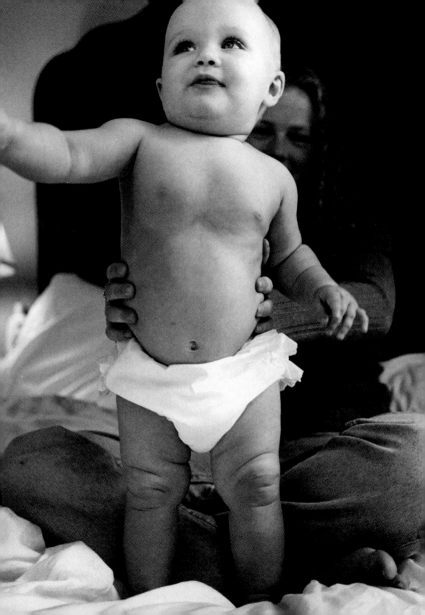

She is a tiny woman, but don't be fooled. She is strong. By her sweet smell and the tinkle of silver bracelets, you know she is there. On her fingers she wears her mother's diamond, her twin sister's gold ring, and her own wedding band. Last year her mother and sister died of ovarian cancer. For the past fourteen years, her hands have tended to the new life of her babies, cleaned up the aftermath of chemotherapy, cooled down bone marrow-transplant fevers, and bathed and dressed the bodies of her sweet sister and mama. After a day of hospital tests, PTA meetings, soccer practice, tears, cooking dinner, late-night calls to say good night and "I love you more," she would pray for miracles and enough strength to give one more day. Her hands and arms are surrounded by silver and gold rings and bracelets. Circles, the symbol of eternal life.

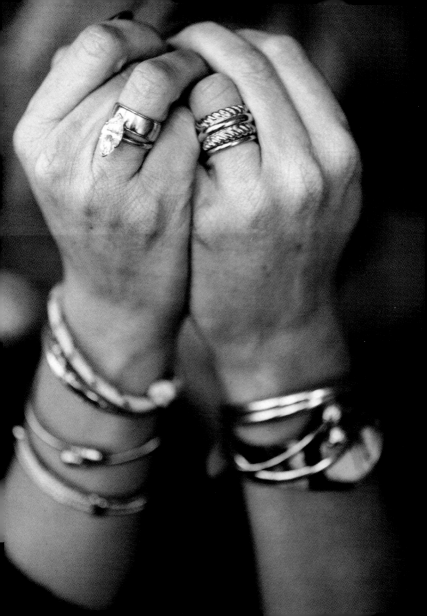

Holding the strands of his children's hair, he cannot tell

you how he feels about fatherhood. His children feel

safe and loved. Divorced when the children were small,

he never left them. Every Wednesday night he was there.

Every weekend he was there. At night he calls to say,

"Sweet dreams." He proudly grins from the front row

at Beta Club inductions, basketball games, school plays,

Christmas choirs, and softball games. When grades

from school aren't as expected, he lectures. When

chores aren't finished, he lectures. Love, consistency,

discipline, and presence. He is a father.

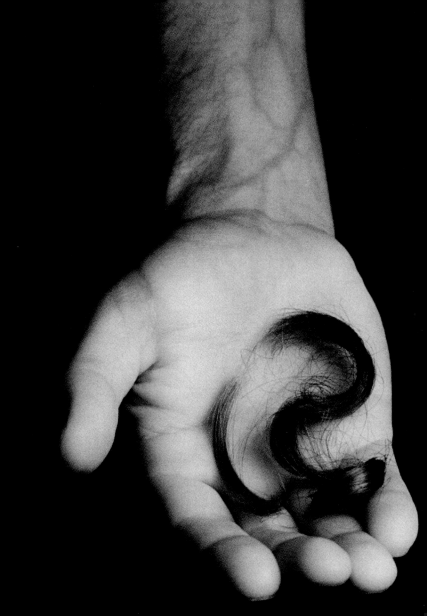

She was adopted at birth. Throughout her life she has wondered about her family of origin. Where did I come from? Did my mother love me? Both of her parents of nurture have passed away. From her father she inherited the compass he used in the service. She may not know where she is from, but with the help of strong family, she knows where she is going.

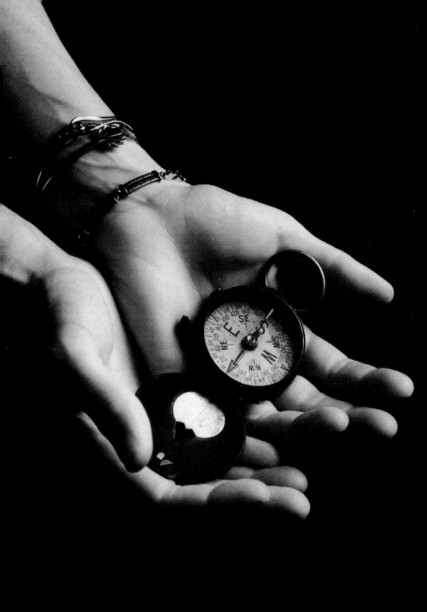

"I am the one trying to get away," she says, holding her hand over her mouth while she laughs. "My parents both came from coal mining people. All they wanted for their children was a better life. They gave me ambition and drive." She grew up on military bases around the world. She attended fourteen schools, yet this confident woman says her life is based on a strong sense of roots. "When you move all the time, your whole life is about family."

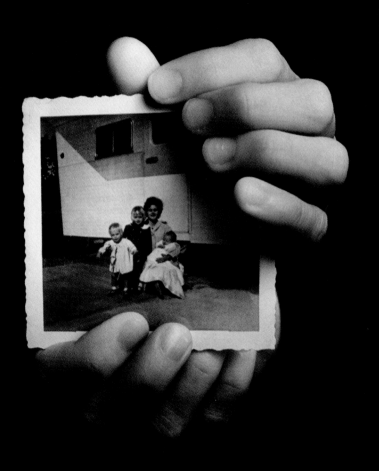

Debra takes Polaroids of her sisters and slips them into her pocket each morning before she leaves for work. At night she looks at pictures of her coworkers, lined up on her bedside table as they stamp and seal envelopes. When asked how her day was, she shows you Polaroids and tells funny stories about her friends. In a large scrapbook at home reside hundreds of pictures of Debra. For all of us, self-knowledge is elusive. Recording her "self" through the years, Debra remembers the child, the teenager, and the woman. It is the way she does memory.

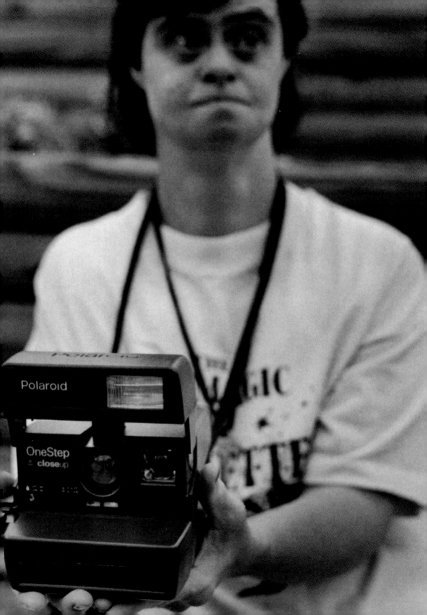

Preaching and screaming the Word, this End Time

evangelist seeks to release us all from Satan's tight grip.

In the Church of Jesus Christ with Signs Following, our

Brother baptizes babies, offers Communion, handles

snakes, anoints, heals, speaks in tongues, washes feet,

and keeps a sharp eye out for the Devil. He found this

owl, dead at the end of his driveway. No wounds scar

this bird. No gunshots, no blows, no infections. Only

death in the presence of a holy man. He keeps it in his

freezer to show sorrowful backsliders the face of evil.

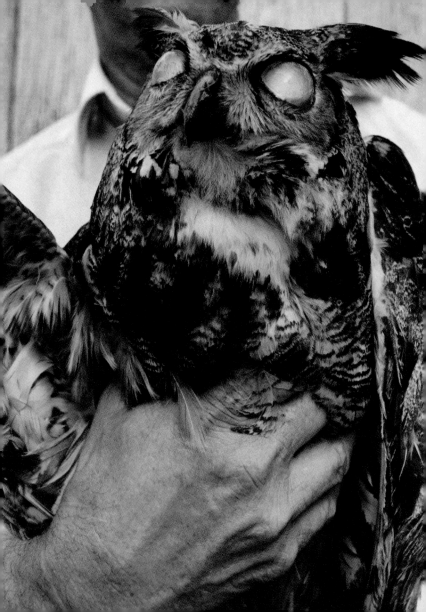

As she holds her mother's ring, memories of her childhood spring back to life. "My mother was the sweetest, dearest woman in the world. If we went to the store, we kissed her good-bye and then hello, as if we had just left and returned from a long journey." Born second in a family of four, she is the last child left. The love of her family still resides in the gestures of this ninety-year-old great-grandmother. It is hard to leave her without a kiss.

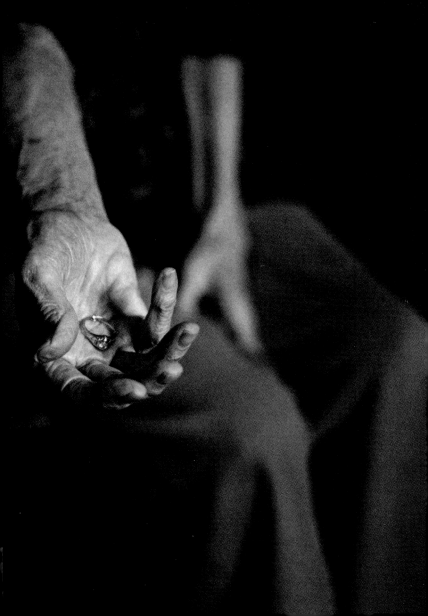

He saved all his baby teeth. It didn't feel right selling

parts of his body to a stranger who came in the night.

With each lost tooth, he would ask his mama to leave

a note addressed to the tooth fairy to explain that he

would like to keep his tooth. He also said that if the

tooth fairy wanted to, she could still leave the quarter.

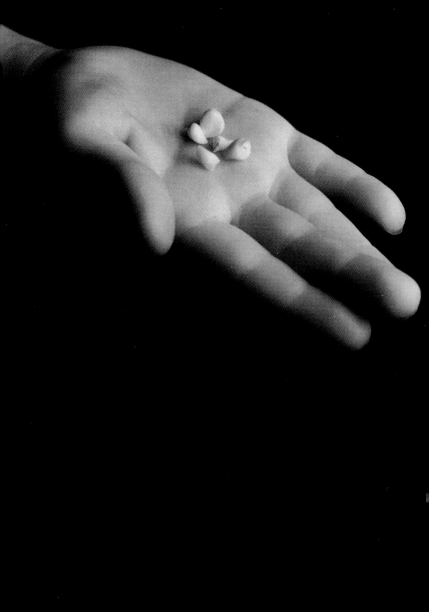

Eve listened, and we were born.

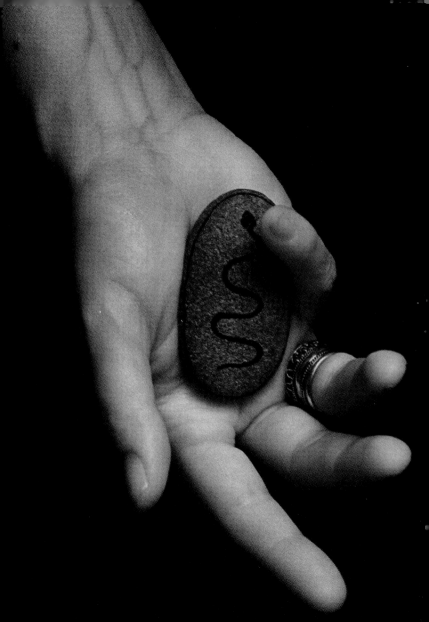

He waited a long time for his dog. When he was four, the divorce happened. "No, Honey, we have to move to an apartment." Later, when the power would be turned off and the checks would come back, his mama would say, "We can't afford a dog." After the remarriage, Phillip was given a puppy. With blue eyes like her master's, this half-sharpei, half-cocker pup sleeps in his room upstairs to guard him from the fears behind the attic door. At three o'clock in the afternoon, she listens for his steps as she waits by the gate.

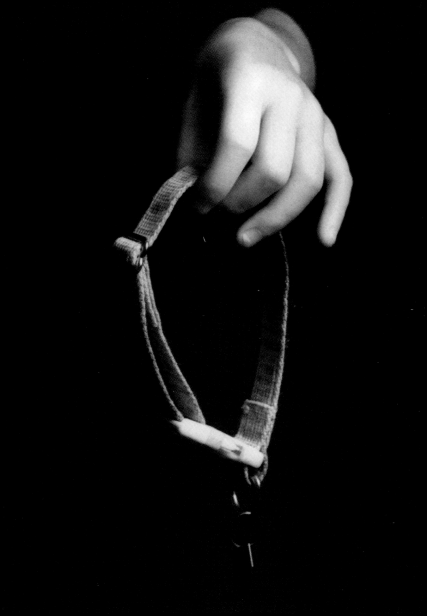

His grown daughters are strong women with compassionate hearts. He is the best of fathers. He held his girls close when they were young. And he opened his arms when the time came for them to leave. As little girls, they each gave him a stone. They wanted to present their father with something beautiful so he would feel delight. He has kept the stones they gave him for years, having been delighted by beauty since his daughters were born.

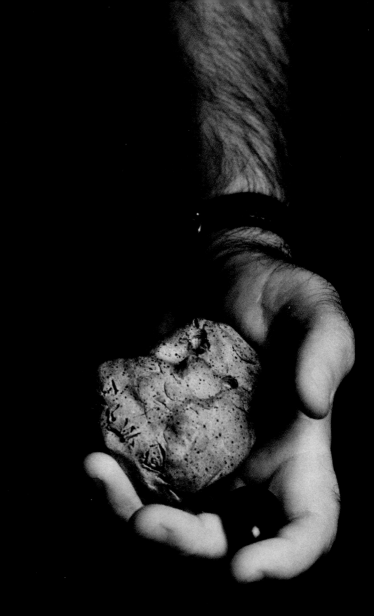

She is my first husband's new wife. At forty-two, she is expecting their first child. We know it's a girl. I had a daughter with this man fifteen years ago, the same month her child is due. I wonder if the baby will look like him. If she does, she will look like one of my babies. During labor my son, my daughter, and I stand vigil in the hospital waiting room. After delivery we are all invited in to see the baby. The new mother smiles at me and hands me a soft pink bundle. I already feel possessive of this baby. She is my children's sister—they share the same blood. I feel related to her. But there is no word for our relationship—she is not my niece or cousin. She opens her eyes and looks around. I decide she is my "sister child."

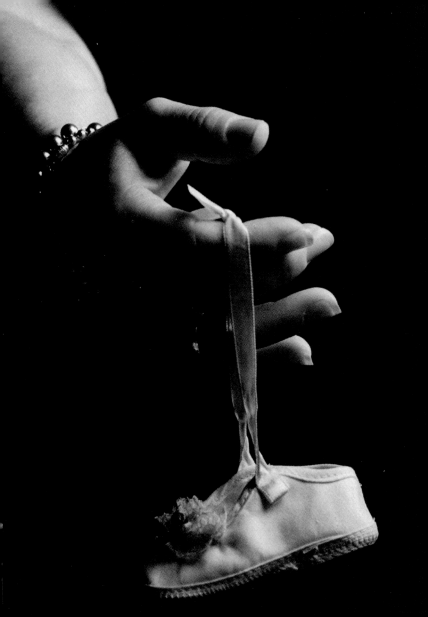

As a Southern child living in Ohio, she was sent every summer to stay with her grandmother in Agricola, Mississippi. This ensured the return of her Southern accent and benefited her spiritual development. Her "Mother Pope" was a staunch fundamentalist, believing in the Word of the King James Version and the plain living of the poor. No pictures were hung in the farmhouse. No frills, no color, nothing remotely sinful could be seen. But under her bed, Mother Pope kept a jar of fancy buttons. Hidden from view under the tall bed, a child's hands would sift through the glamor of rhinestones, pearls, and bright paint. She would imagine the dresses those buttons once adorned and the women who wore them on magic nights. As an adult, this little girl still loves buttons. They give her the opportunity once again to hold fairy tales in her hands.

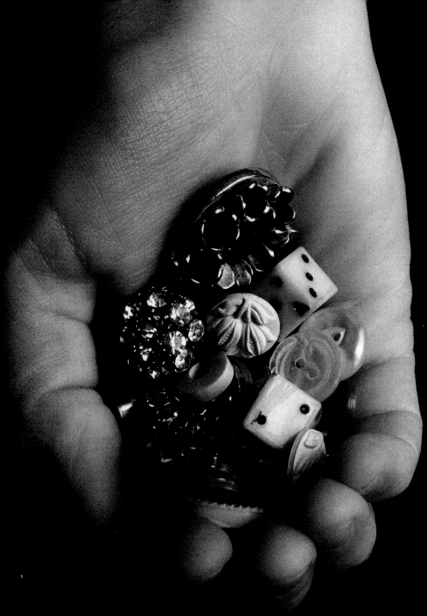

She takes the parts she needs. She pulls from the philosophies of West and East—and does not forget her Catholic childhood. She learned how to cook from her father, how to practice yoga from her mother, and how to find good produce from her grandfather. Her lotus hand holds Buddha's head. She is mindful.

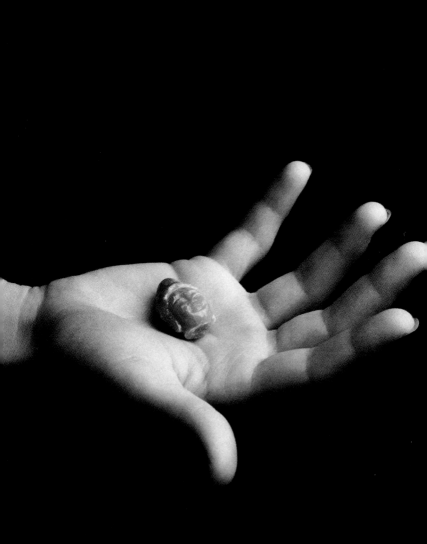

The son holds the heart his father carved as a boy.

The son never knew his father. Sometimes his mother

tells him stories. His father was a kind man. He was

killed in a car accident three months before the baby

came. It was the early sixties. No one stopped to help.

They only stood around and wondered why a good

Southern soldier would give a ride to a black man. Two

soldiers dying in the Alabama sun. His father was good,

compassionate, and strong. He keeps this carved heart

to remind himself that he is his father's son.

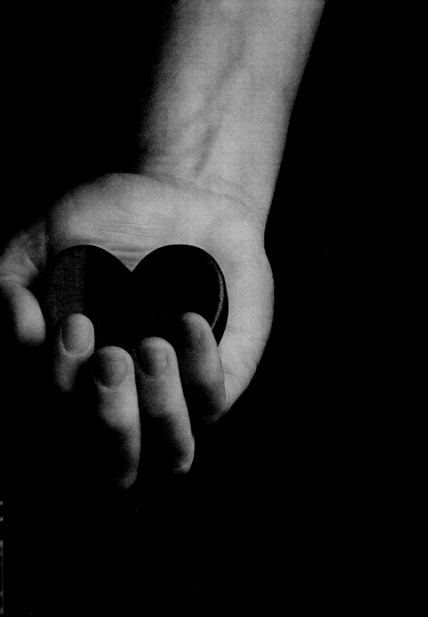

In prison, no yellow porch light welcomes home the weary. In prison, home is in letters still smelling of the bacon mama fried before she sat down to write that morning. On old notebook paper, an inmate draws the floor plans of her childhood house. She carefully sketches each piece of furniture in its proper place and hangs the family pictures over the fireplace mantel. Every day this blueprint takes her back to her old room. In letters to family, she draws a self-portrait. Two days later a small flat slip of herself is pushed through the mail slot, sliding to the foyer floor. Home.

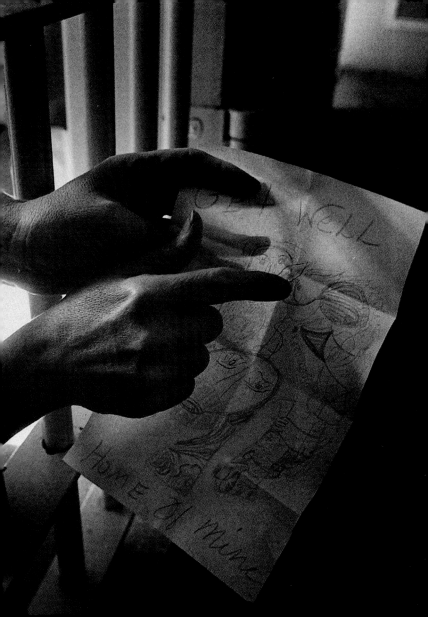

This four-year-old girl knows how to survive. She was

left on the street in Pushkar, India, when she was two.

For her, money is not about greed, but about food.

When I take my walks every morning by the ghats,

she slips up beside me and takes my hand. We walk in

silence. Before I leave her village, I show her a snapshot

of my two children sitting in front of the Christmas tree.

She begs me to give it to her. In exchange, she reaches

into her pocket and pulls out five grapes, insisting that

I take them. The child slips away, clutching the picture

of children who are loved.

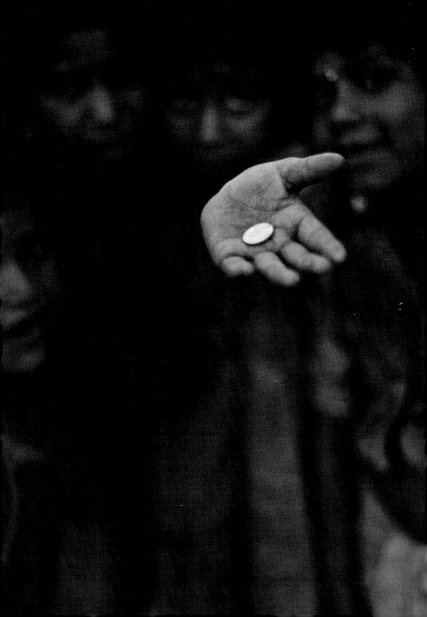

Om mani padme hum. Om mani padme hum.
Om mani padme hum.

The sounds of a Buddhist prayer room enter your
spine and migrate to your brain. The mantra literally
means "mind protection." A hundred men and women
send prayers around the world by spinning their prayer
wheels. They sit on the floor, rocking back and forth.
Turning the prayer wheel and repeating the mantra lasts
all morning. Butter tea is taken once for nourishment.
Since May of the year 528 B.C., when Buddha received
Enlightenment, the prayers for compassion have moved
relentlessly through the trees, riding the earth's wind.
Prayers for the equality of all people lap onto all shores
with the incoming tides. The prayers for kindness sit
patiently in prison cells and concentration camps,
bearing witness to man's suffering.

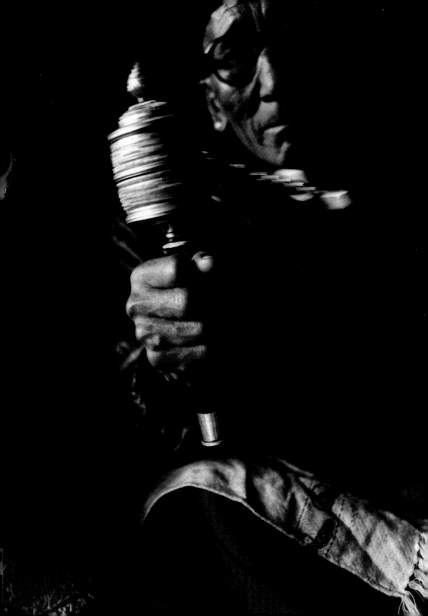